mā

the pocke

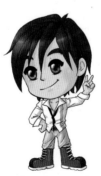

Yishan Li

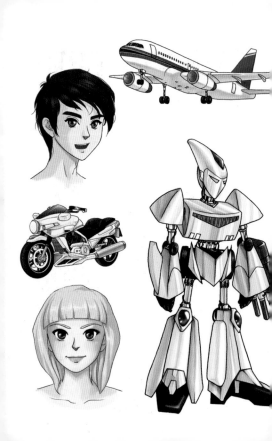

manga tips

the pocket reference to drawing manga

Yishan Li

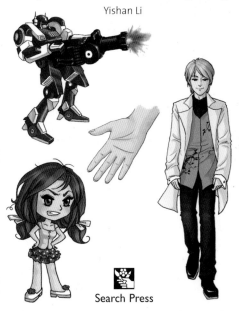

Search Press

First published in Great Britain 2010 by
Search Press Limited
Wellwood, North Farm Road,
Tunbridge Wells, Kent TN2 3DR

Created and conceived by
Axis Publishing Limited
8c Accommodation Road
London NW11 8ED
www.axispublishing.co.uk

Creative Director: Siân Keogh
Editor: Anna Southgate
Art Director: Sean Keogh
Production Manager: Jo Ryan

ISBN: 978-1-84448-520-8

contents

Introduction

Manga has become a popular art form across the globe. It originated in Japan and the term is actually the Japanese word for 'comic', as it was in Japanese comic strips that such characters were first seen (illustrated film versions of similar characters are known as anime, from the Japanese word for animation).

manga style

The huge popularity of manga has much to do with the content of the comic-strip stories. Invariably this involves a moralistic tale of good versus evil, in which good inevitably claims victory. Along the way, characters face challenges and encounter strange beings that look set to obstruct their goal. What is unique about the form is the

element of rebellion in the way that characters are portrayed: hideous-looking monsters turn out to be innocent, weak and friendly, while an attractive, sporty young girl might be a devious, dangerous foe. Many of the stories involve trickery and duplicity as complex characters use special powers, weapons and strategies to pitch their wits against one another. What stands out about manga art is the appearance of

A typical manga character. Features are youthful and androgynous. The eyes are exaggerated in both size and shape.

the 'human' looking characters. Although often drawn to familiar scale and proportion, their forms are somehow exaggerated. The most obvious example of this is the way in which the eyes are so much bigger than human eyes. They dominate the face of a character, while the other facial features are pared back to exaggerate the look even further. There is often a great deal of ambiguity, too; with super-skinny girls and pretty boys making it difficult, sometimes, to determine a character's gender.

drawing manga art

In order to draw your own manga characters, you will need some very basic art materials (see pages 12–19) but a vivid imagination is just as

important. it is a also a good idea to get to grips with the key manga characteristics outlined above, and that is where this book comes in. Step by step, the instructions on the following pages show you how to draw convincing manga characters, – from the very first rough sketch to finished artwork. You will learn how to draw male and female figures in a range of different postures, making sure you get proportion and perspective right. There are also step-by-step instructions for drawing faces accurately from

*Drawing manga characters
can be achieved in a few
basic steps. Colouring is
often minimal, with
cautious placement of
shadows and highlights.*

different view points and for drawing realistic hands and feet.

When it comes to making your characters individual, you will find all manner of step instructions for different facial features, hairstyles, and clothing for both boys and girls. To extend your characters even further, there are numerous step-by-step instructions for the kinds of weapons they may need to use in their adventures – handguns, swords, a bow and arrow – as well as the transport they might need for getting about – motorbikes, cars and helicopters.

And to complete the picture, there are step instructions for drawing the powerful, menacing manga Mecha robots that your characters might find themselves facing as they journey forth on their quest.

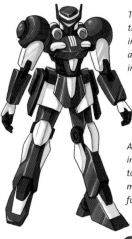

Tall, powerful and angry, the Mecha robots exude an invincibility. Their features are typically harsh and impenetrable.

A good imagination is invaluable when it comes to creating the menacing manga robots with their futuristic-looking weapons.

equipment

In order to create your own manga art, it is a good idea to invest in a range of materials and equipment. The basics include paper for sketches and finished artworks, pencils and inking pens for drawing, and colour pencils, markers or paints for finishing off. There are also a handful of drawing aids that will help produce more professional results.

drawing

Every manga character must start with a pencil sketch – this is essential. You need to build each figure gradually, starting with a structural guide and adding body features, then clothes, in layers. The best way to do this effectively is by using a pencil.

pencils

You can use a traditional graphite pencil or a mechanical one according to preference. The advantages of the latter are that it comes in different widths and does not need sharpening. Both sorts are available in a range of hard leads (1H to 6H) or soft leads (1B to 6B); the higher the number in each case, the harder or softer the pencil. An HB pencil is halfway between the two ranges and will give you accurate hand-drawn lines. For freer, looser sketches, opt for something softer – say a 2B lead. Some of the sketches in this book are drawn using a blue lead. This is particularly useful if you intend to produce your artworks digitally, as blue does not show up when photocopied or scanned. If you opt for a traditional graphite pencil, you will also need a pencil sharpener.

An eraser or putty eraser is an essential tool. Use it to remove and correct unwanted lines or to white-out those areas that need highlights. Choose a good-quality eraser that will not smudge your work.

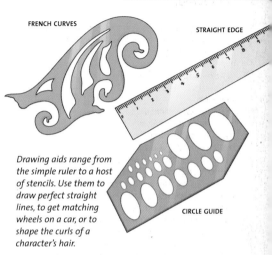

FRENCH CURVES

STRAIGHT EDGE

CIRCLE GUIDE

Drawing aids range from the simple ruler to a host of stencils. Use them to draw perfect straight lines, to get matching wheels on a car, or to shape the curls of a character's hair.

drawing aids and guides

The tips in this book show you how to draw convincing manga characters from scratch by hand. There may be times, however, when drawing by hand proves a little too difficult. Say your composition features a futuristic city scape; you might want to use a ruler to render the straight edges of the buildings more accurately. The same could be true if you wanted to draw more precise geometric shapes – a true circle for the sun, for example.

inking and colouring

Once you have drawn your manga character in pencil, you can start to add colour. This is where you can really let your imagination run free. There are numerous art materials available for inking and colouring, and it pays to find out which ones suit you best.

inking

A good manga character relies on having a crisp, clean, solid black outline, and the best way to achieve this is by using ink. You have two choices here. First is the more traditional technique, using pen and ink. This involves a nib with an ink cartridge, which you mount in a pen holder. The benefit of using this method is that you can vary the thickness of the strokes you draw, depending on how much pressure you apply as you work. You also tend to get a high-quality ink. The alternative to using pen and ink is the felt-tipped drawing pen, which comes in a range of widths. A thin-nibbed pen (0.5mm) is best, but it is also a good idea to have a medium-nibbed pen (0.8mm) for more solid blocks of ink. Whichever option you go for, make sure the ink is quick-drying and/or waterproof so that it does not run or smudge as you work.

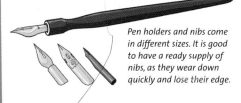

Pen holders and nibs come in different sizes. It is good to have a ready supply of nibs, as they wear down quickly and lose their edge.

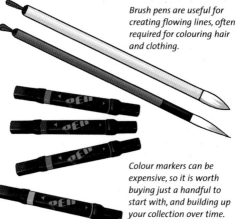

Brush pens are useful for creating flowing lines, often required for colouring hair and clothing.

Colour markers can be expensive, so it is worth buying just a handful to start with, and building up your collection over time.

colouring

There are various options available to you when it comes to colouring your work. The most popular method is to use marker pens. These are fast-drying and available in very many colours. You can use them to build up layers of colour, which really helps when it comes to creating shading in, say, hair or clothing. You can also use colour pencils and paints very effectively (gouache or watercolour). Colour pencils and watercolours are probably the most effective media for building up areas of tone – say for skin – and also for blending colours here and there. White gouache is very useful for creating highlights, and is best applied with a brush.

papers

It is difficult to imagine that you will have the perfect idea for a character every time you want to draw a manga scenario. These need to be worked at – not just in terms of appearance – but also in terms of personality. It is a good idea, therefore, to have a sketchbook to hand so that you can try out different ideas. Tracing paper is best for this, as its smooth surface allows you to sketch more freely. You can also erase unwanted lines several times over without tearing the paper. A recommended weight for tracing paper is 90gsm.

Having sketched out a few ideas you will want to start on a proper composition, where you move from pencil outline to inked drawing to finished coloured art. If you are tracing over a sketch you have already made, it is best to use paper that is slightly opaque, say 60gsm. In order to stop your colours bleeding as you work, it is important that you buy 'marker' or 'layout' paper. Both of these are good at holding colour without it running over your inked lines and blurring the edges. 'Drawing' paper is your best option if you are using just coloured pencils with the inked outline, while watercolour paper is, of course, ideal for painting with watercolour – a heavyweight paper will hold wet paint and colour marker well. You also have a choice of textures here.

It is always best to allow space around the edge of your composition, to make sure that the illustration will fill the frame.

20мм

TRIM

20мм

IMAGE AREA
(SAFETY ZONE)

20мм

TRIM SPACE

20мм

using a computer

The focus of this book is in learning how to draw and colour manga characters by hand. Gradually, by practising the steps over and again you will find that your sketches come easily and the more difficult features, such as hands, feet and eyes, begin to look more convincing. Once that happens, you will be confident enough to expand on the range of characters you draw. You might even begin to compose cartoon strips of your own or, at the very least, draw compositions in which several characters interact with each other – such as a battle scene.

Once you reach this stage, you might find it useful to start using a computer alongside your regular art materials. Used with a software program, like Adobe Photoshop, you can colour scanned-in sketches quickly and easily. You will also have a much wider range of colours to use, and can experiment at will.

Any home computer can be used for colouring your manga sketches in order to produce finished art.

You can input a drawing straight into a computer programme by using a graphics tablet and pen. The tablet plugs into your computer, much like a keyboard or mouse.

Moving one step further, a computer can save you a lot of time and energy when it comes to producing comic strips. Most software programs enable you to build a picture in layers. This means that you could have a general background layer – say a mountainous landscape – that always stays the same, plus a number of subsequent layers on which you can build your story. For example, you could use one layer for activity that takes place in the sky and another layer for activity that takes place on the ground. This means that you can create numerous frames simply by making changes to one layer, while leaving the others as they are. There is still a lot of work involved, but working this way does save you from having to draw the entire frame from scratch each time.

Of course, following this path means that you must invest in a computer if you don't already have one. You will also need a scanner and the relevant software. All of this can be expensive and it is worth getting your hand-drawn sketches up to a fairly accomplished level before investing too much money.

the tips

The following pages show you all the basics of manga art, from drawing the male and female figures from all angles, and in a variety of poses, to creating different hairstyles, and facial details and expressions. There are sections on how to deal with different articles of clothing. We also show you how to draw a selection of weapons and vehicles, and finally mecha. All you need to create exciting manga.

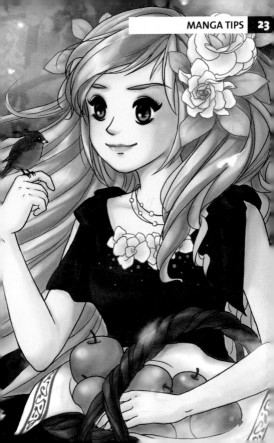

female proportions

Realistic proportions are key when it comes to drawing the female figure. They provide a 'skeleton' on which to build.

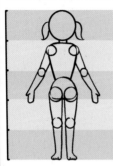

You can divide the young female figure into five equal portions. The head makes up one-fifth of the body, while upper body (shoulder to thigh) and lower body (legs) each make up two-fifths.

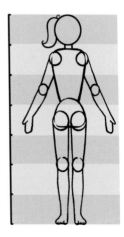

You can divide the adult female figure into seven equal portions along similar lines. Notice, how much longer the legs are now, compared to the upper body.

In general, the younger the character, the bigger the head in relation to the body; compare the head of the adult figure here to that of the young female figure opposite.

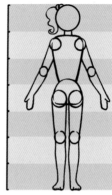

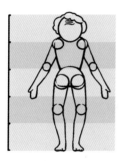

Draw an older woman by dividing her body into five equal portions. Notice that the head and torso make just one portion each.

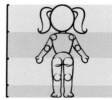

When drawing a Chibi, make her head much bigger, proportionately, than for any other female figure – almost one-third of her body size.

young girl standing

Draw a young girl with a slim figure using a head-to-body ratio of at least 1:6, but no more than 1:9.

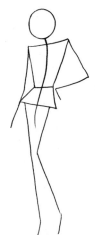

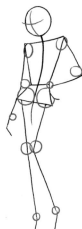

2 Still using pencil, draw in simple guidelines for the facial features (see pages 64–65). Draw basic shapes at the shoulders, elbows and so on, to show where the joints should be.

1 Decide on the stance you want your girl to have and sketch a very rough structure using a pencil. Consider proportions carefully (see page 24–25).

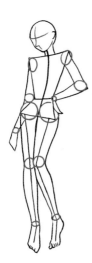

4 Start to add some detail. Use the pencil to draw in some simple facial features and a rough outline of the girl's hair. Give more shape to the chest and hands.

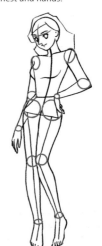

3 Now add more detail to the basic structure that you have drawn so far. Give the girl a simple pencil outline, bearing in mind the more curvaceous shape of the female body.

▶▶

young girl standing continued

5 Build on the three-dimensionality of your figure, giving the body more form. Draw the girl's hair in greater detail. Erase the structure lines you drew in steps 1–4.

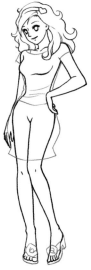

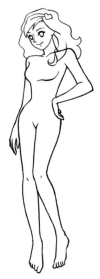

6 Still using the pencil, begin to draw basic outlines for the girl's clothes – (see pages 122–133 for inspiration). Consider perspective carefully when adding clothes and the shoes.

7 Once the pencil drawing is complete, you can finalise it using black ink. Take care to draw over your lines accurately, adding any last details, such as the folds in the material.

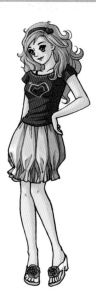

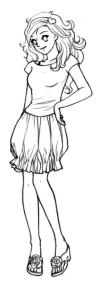

8 Now you can add colour to your drawing, taking care to capture highlights and shadows. Take particular care over the facial features (see pages 56–71 for tips and techniques).

young girl sitting

Whatever position your figure has when sitting, the principles for drawing her remain the same.

1 Start by sketching a very rough structure using a pencil. Use a head-to-body ratio of at least 1:6 (see pages 24–25 for guidance).

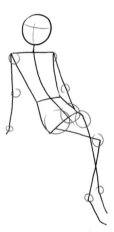

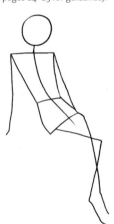

2 Still using pencil, draw very basic shapes at the shoulders, elbows, wrists and so on, to show where the joints should be. Draw in simple guidelines for the facial features (see pages 64–65).

3 Add more detail to the basic structure that you have drawn so far. Give the girl a simple pencil outline, bearing in mind the more curvaceous shape of the female body. Draw the outline of her hair.

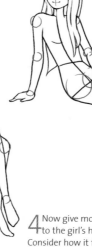

4 Now give more shape to the girl's hair. Consider how it flows around her face and over her shoulders (see pages 96–97 for tips).

▶▶

young girl sitting continued

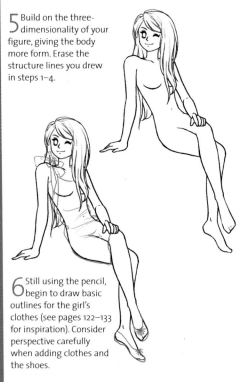

5 Build on the three-dimensionality of your figure, giving the body more form. Erase the structure lines you drew in steps 1–4.

6 Still using the pencil, begin to draw basic outlines for the girl's clothes (see pages 122–133 for inspiration). Consider perspective carefully when adding clothes and the shoes.

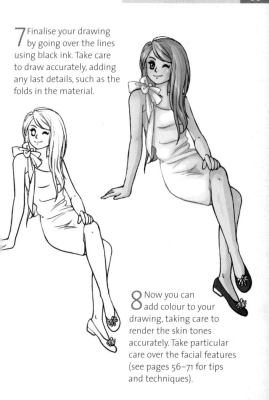

7 Finalise your drawing by going over the lines using black ink. Take care to draw accurately, adding any last details, such as the folds in the material.

8 Now you can add colour to your drawing, taking care to render the skin tones accurately. Take particular care over the facial features (see pages 56–71 for tips and techniques).

sweet chibi

Chibis typically have large, round heads and over-sized facial features. It is this that gives them their cute appearance.

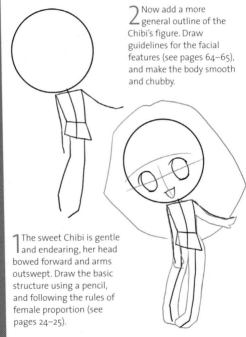

2 Now add a more general outline of the Chibi's figure. Draw guidelines for the facial features (see pages 64–65), and make the body smooth and chubby.

1 The sweet Chibi is gentle and endearing, her head bowed forward and arms outswept. Draw the basic structure using a pencil, and following the rules of female proportion (see pages 24–25).

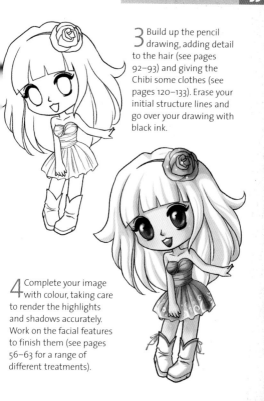

3 Build up the pencil drawing, adding detail to the hair (see pages 92–93) and giving the Chibi some clothes (see pages 120–133). Erase your initial structure lines and go over your drawing with black ink.

4 Complete your image with colour, taking care to render the highlights and shadows accurately. Work on the facial features to finish them (see pages 56–63 for a range of different treatments).

angry chibi

Once you have mastered the Chibi, you can begin to experiment with different expressions. Here, she is angry.

2 Use your basic structure to build a fuller outline of your Chibi's figure. Draw guidelines for facial features (see pages 64–65), and make the body smooth and chubby.

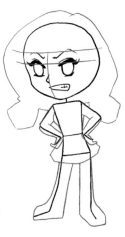

1 Draw the basic structure using a pencil, and following the rules of female proportion (see pages 24–25). Think about your Chibi's body language as well as the expression on her face.

3 Still using pencil, fill in more detail for the Chibi's hair (see pages 92–96) and clothing (see pages 120–133). Erase your initial structure lines and go over your drawing with black ink.

4 Complete your image with colour. Consider areas of light and shade carefully, as these will make your image more realistic and three-dimensional.

GALLERY

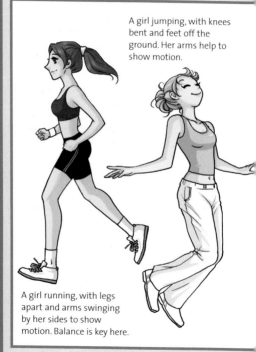

A girl jumping, with knees bent and feet off the ground. Her arms help to show motion.

A girl running, with legs apart and arms swinging by her sides to show motion. Balance is key here.

When drawing a side view, it is important to keep it three-dimensional. Adding just a glimpse of the far leg helps to do this.

Perspective is key when drawing figures from above or below. Here, the feet are further away than the head and so appear smaller.

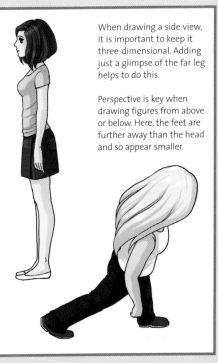

male proportions

Realistic proportions are key when it comes to drawing the male figure, and provide a 'skeleton' on which to build.

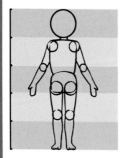

You can divide the young male figure into five equal portions. The head makes up one-fifth of the body, while upper body (shoulder to thigh) and lower body (legs) each make up two-fifths.

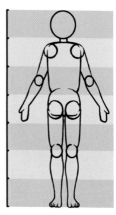

You can divide the adult male figure into seven equal portions along similar lines. The torso (shoulder to waist) makes up two portions, while the lower body (hips and legs) makes up four portions.

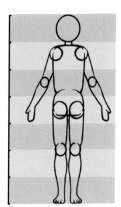

Children and old people tend to have a big head in relation to the rest of their body; compare the head of the adult figure (left) to that of the boy (opposite) and the older man (below).

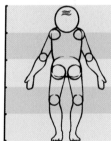

A Chibi's head is larger still, proportionately – almost one-third of his whole body size.

young man walking

When drawing young adult figures, use a head-to-body ratio of at least 1:6, but no more than 1:9.

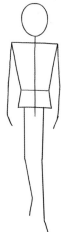

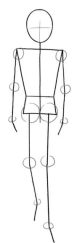

2 Still using pencil, draw in simple guidelines for the facial features (see pages 80–81). Draw basic shapes at the elbows, hips, knees and so on, to show where the joints should be.

1 Sketch a very rough structure of your man using a pencil. Get your proportions right (see page 40–41) and draw the rear leg slightly bent in order to show motion.

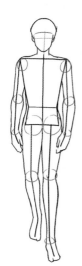

4 Use the pencil to draw in some simple facial features and a rough outline of the man's hair. Give more shape to the chest and hands.

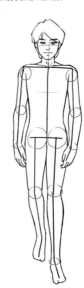

3 Continue to add detail to your basic structure. Give the man a simple pencil outline, paying particular attention to the more muscular areas.

▶▶

young man walking continued

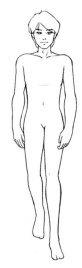

6 Still using the pencil, begin to draw basic outlines for the man's clothes (see pages 134–147 for inspiration). Make sure that your lines reflect the movement of the man's body.

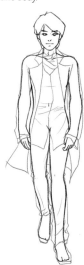

5 Build on the three-dimensionality of your figure, giving the body more form. Refine any of the lines if you need to. Erase the structure lines you drew in steps 1–4.

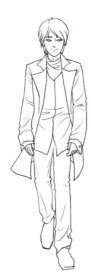

8 Now you can add colour to your drawing. Consider highlights and shadows carefully to show how his clothes catch the light as he moves forward.

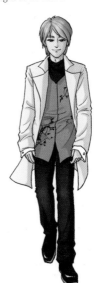

7 Once the pencil drawing is complete, you can finalise it using black ink. Take care to draw over your lines accurately, adding any last details, such as the folds in the material.

young man boxing

For your figures to be convincing, it is important that you can draw them doing a wide range of activities.

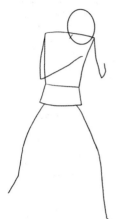

2 Still using pencil, draw very basic shapes at the shoulders, hips, knees and so on, to show where the joints should be. Draw in simple guidelines for the facial features (see pages 80–81).

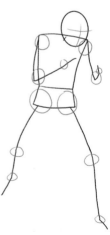

1 Sketch a very rough structure using a pencil. Pay particular attention to the man's stance and where his head is in relation to the rest of his body. Get your proportions right (see page 40–41).

4 Use the pencil to draw in some simple facial features and a rough outline of the man's hair. Draw the hair in such a way that it gives the impression of movement.

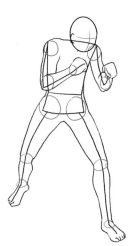

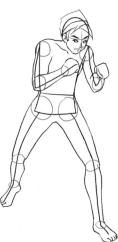

3 Add more detail to the basic structure that you have drawn so far. Give the man a simple pencil outline, bearing in mind that his body should be strong and muscular.

▶▶

young man boxing continued

5 Build on the three-dimensionality of your figure, giving his body more form. Refine any of the lines if you need to. Erase the structure lines you drew in steps 1–4.

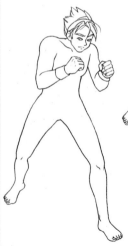

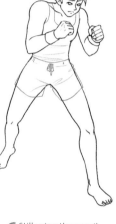

6 Still using the pencil, begin to draw basic outlines for the man's clothes – he needs just a tight vest and shorts (see pages 134–147).

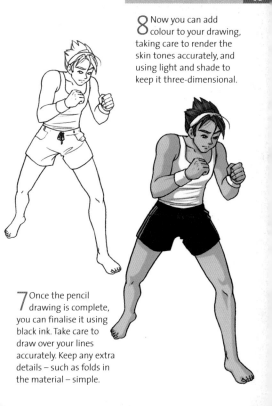

8 Now you can add colour to your drawing, taking care to render the skin tones accurately, and using light and shade to keep it three-dimensional.

7 Once the pencil drawing is complete, you can finalise it using black ink. Take care to draw over your lines accurately. Keep any extra details – such as folds in the material – simple.

male chibi

Chibi's have big eyes, which makes it hard to tell their gender. Here's how to make a Chibi more male-looking.

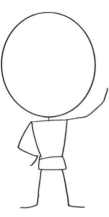

2 Still using pencil, draw in simple guidelines for the facial features (see pages 80–81). Draw basic shapes at the elbows, hips, knees and so on, to show where the joints should be.

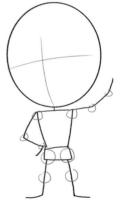

1 Start by giving your Chibi a confident stance – back straight, hand on hip. Draw the basic structure using a pencil, and following the rules of male proportion (see pages 40–41).

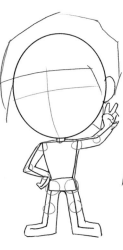

4 Continue to build on the detail. Concentrate on getting the hair and facial features right (see pages 72–79 and 98–101). Give your Chibi thick eyebrows to make him look more masculine.

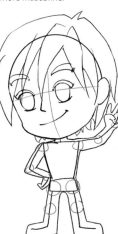

3 Now add a more general outline of the Chibi's figure. Give him big hair and make his body smooth and chubby.

▶▶

male chibi continued

5 Build on the three-dimensionality of your Chibi, giving the body more form. When happy with you basic outline, erase the structure lines you drew in steps 1–4.

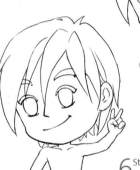

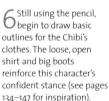

6 Still using the pencil, begin to draw basic outlines for the Chibi's clothes. The loose, open shirt and big boots reinforce this character's confident stance (see pages 134–147 for inspiration).

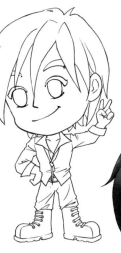

8 Complete your image with colour, taking care to render the highlights and shadows accurately. This will give your Chibi a more realistic, three-dimensional appearance.

7 Once the pencil drawing is complete, you can finalise it using black ink. Take care to draw over your lines accurately, making slight adjustments here and there for greater authenticity.

GALLERY

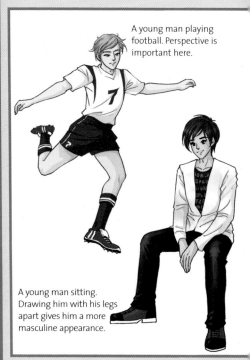

A young man playing football. Perspective is important here.

A young man sitting. Drawing him with his legs apart gives him a more masculine appearance.

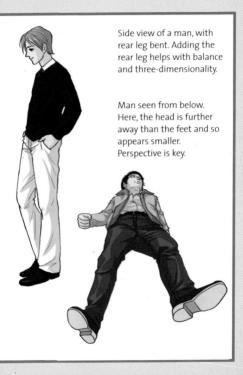

Side view of a man, with rear leg bent. Adding the rear leg helps with balance and three-dimensionality.

Man seen from below. Here, the head is further away than the feet and so appears smaller. Perspective is key.

the female eye

Manga eyes are wider (below centre) and taller (below right) than the real thing (below left). Consider different angles.

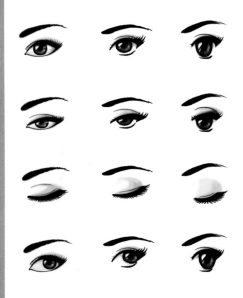

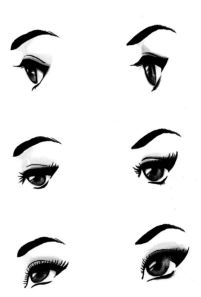

the female eye

Here is a female manga eye, looking straight on. Remember to reverse your lines for the opposite side of the face.

1 Start with a basic outline of the eye, using pencil. Draw in the oval eye shape, slanting upwards towards where the edge of the face would be. Add a simple eyebrow line that follows the shape of the eye.

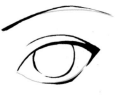

2 Build on your outline using black ink. Make the eyebrow slightly thicker at the end nearest the nose. Draw simple outlines for the iris and eyelids. Keep lines minimal a prettier effect.

3 Give more shape and definition to the eyebrow. Use the ink to build depth into the outer corner of the eye, to give an impression of make-up.

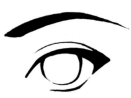

4 Complete the black ink drawing by adding final details, such as the eyelashes. Make these longer at the outside corner of the eye, for a more realistic appearance.

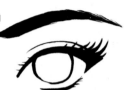

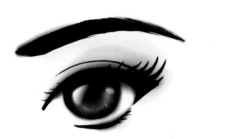

5 Now you can add colour to your drawing, bearing in mind where to leave the paper white for highlights. Build the colour in layers, taking care not to overdo it.

the female nose

In manga art, noses are often rendered very simply, using just a few lines and subtle shading.

1 A realistic nose, drawn face on. This kind of nose is not often used in manga art, as it tends to compete with the over-sized eyes so typical of the genre. See opposite for the side view and 45-degree angle.

2 A shaded nose, simpler and better for manga art. Instead of drawing the physical shape of the nose itself, you focus more on its shadow. See opposite for the side view and 45-degree angle.

3 A very simple nose, this requires very little line work at all. This relies on good shading and the drawing in of the two nasal holes. See opposite for the side view and 45-degree angle.

the female mouth

Female mouths can be realistic (below) or simplified (opposite), depending on the character you are building.

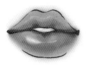

Realistic-looking lips, perhaps a little fuller than normal, are great for using on the more sexy female characters. Use a darker outline to give definition.

True-to-life lips, where the colouring is close to a skin tone. Notice the top lip is much thinner than the bottom lip for a less sexy look.

Realistic lips, drawn from the side view, and using a thin black outline to give definition.

Slightly fuller lips, although still realistic, drawn from the side view. The lack of black outline gives the lips a more sexy appearance.

The female mouth in its simplest form. There is barely any shape to the lips at all, and just a small line to give definition to the chin.

A less realistic, cartoon-like mouth from the side view. This is a good option for a character who is singing or calling out. Note the perspective, where only the top teeth are visible.

A less realistic, cartoon-like mouth, face on. Again, note the perspective here. With this mouth, and the side view above, there is no need to draw in any lips.

A simple female mouth drawn side on. There is just one inked line for definition, and a small highlight to show form.

the female head

It is useful to know how to draw a woman's head face on. There are also a few tips for making it easier.

1 Using a pencil, draw a neat, even oval shape – you could even use a stencil for this. Divide your oval into four equal portions, using a ruler if you prefer.

2 Using the guidelines to help you, give your face more shape. Make it taper towards a point at the chin, centred on the vertical guide. Draw ears at the sides, roughly in line with the horizontal guide.

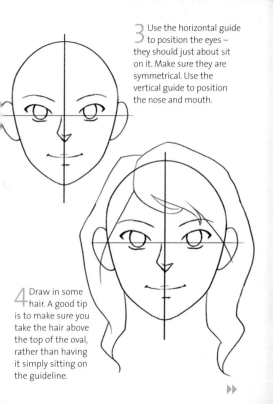

3 Use the horizontal guide to position the eyes – they should just about sit on it. Make sure they are symmetrical. Use the vertical guide to position the nose and mouth.

4 Draw in some hair. A good tip is to make sure you take the hair above the top of the oval, rather than having it simply sitting on the guideline.

▶▶

the female head continued

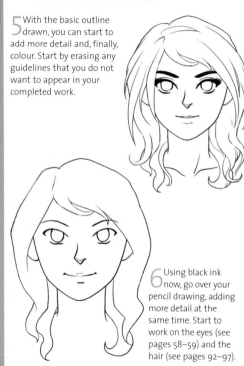

5 With the basic outline drawn, you can start to add more detail and, finally, colour. Start by erasing any guidelines that you do not want to appear in your completed work.

6 Using black ink now, go over your pencil drawing, adding more detail at the same time. Start to work on the eyes (see pages 58–59) and the hair (see pages 92–97).

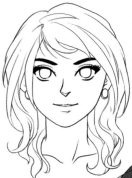

7 Continue to add detail to the hair, keeping it natural looking. Draw in a few lines to suggest clothing and/or jewellery.

8 With the ink work complete you can now colour your drawing. Pay particular attention to areas of light and shade, and remember to leave the paper white where you want highlights.

female head: side view

Drawing the female head from the side uses similar principles as drawing the female head face on.

1 Draw an oval. This time, angle it a little to one side. When drawing in your guidelines, move them slightly off-centre, towards the back of the head.

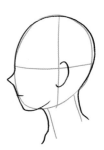

2 Give more shape to the head, adding a nose and neckline. Position the ear roughly where the guidelines meet.

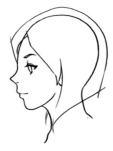

3 Now add a rough outline for the hair, and draw in your facial features. (See page 57 for drawing eyes in profile, and page 63 for the mouth).

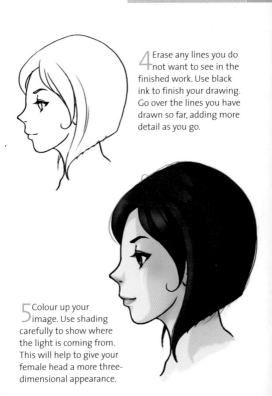

4 Erase any lines you do not want to see in the finished work. Use black ink to finish your drawing. Go over the lines you have drawn so far, adding more detail as you go.

5 Colour up your image. Use shading carefully to show where the light is coming from. This will help to give your female head a more three-dimensional appearance.

female head: 45 degrees

Once you are drawing manga characters regularly, this is probably the view you will use most.

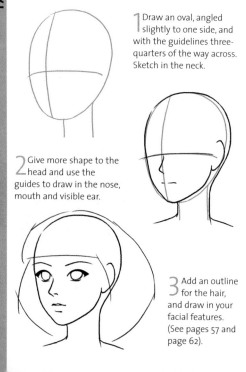

1 Draw an oval, angled slightly to one side, and with the guidelines three-quarters of the way across. Sketch in the neck.

2 Give more shape to the head and use the guides to draw in the nose, mouth and visible ear.

3 Add an outline for the hair, and draw in your facial features. (See pages 57 and page 62).

4 Erase any lines you do not want to see in the finished work. Use black ink to go over the lines you have drawn so far and add more detail as you go.

5 Colour up your image. Use shading carefully to give more definition to the face and to keep it looking three-dimensional.

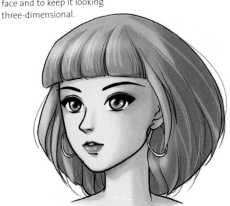

male eye treatments

Eyes for male manga characters tend to be smaller than those for females, and more angular, with thicker eyebrows.

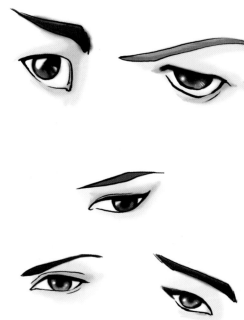

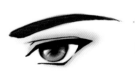
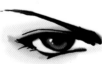

the male eye

Here is a typical male manga eye, looking straight on. Reverse the drawing for the opposite side of the face.

1 Start with a basic outline of the eye, using pencil. Draw in the oval eye shape, slanting upwards towards where the edge of the face would be. Add a simple eyebrow line that follows the shape of the eye.

2 Build on your outline using black ink. Give more shape and definition to the eyebrow. Draw simple outlines for the iris and eyelids.

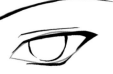

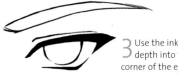

3 Use the ink to build depth into the outer corner of the eye.

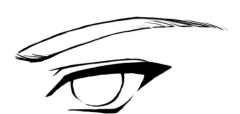

4 Complete the black ink drawing by adding final details, such as a little shading in the eyebrow.

5 Now you can add colour to your drawing, bearing in mind where to leave the paper white for highlights. Build the colour in layers, taking care not to overdo it.

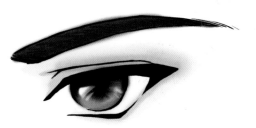

the male nose

As with the female face, male noses are often rendered very simply, using just a few lines and subtle shading.

1 A realistic nose, drawn face on. This kind of nose is used for more muscular men in manga art. See opposite for the side view and 45-degree angle.

2 A shaded nose, simpler and better for manga art. Instead of drawing the physical shape of the nose itself, you focus more on its shadow. See opposite for the side view and 45-degree angle.

3 A very simple nose, this requires very little line work at all. See opposite for the side view and 45-degree angle.

the male mouth

Male mouths can be realistic (top) or simplified (centre and bottom), depending on the character you are building.

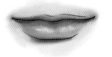

1 True-to-life lips, with the top lip thinner than the bottom lip. See opposite for the side view and 45-degree angle.

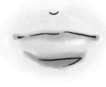

2 Simplified lips, where just a few lines and careful shading are used to give definition. See opposite for the side view and 45-degree angle.

3 The male mouth in its simplest form, with barely any shape to the lips at all. See opposite for the side view and 45-degree angle.

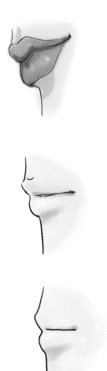
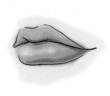

the male head

It is useful to know how to draw a man's head face on. There are also a few tips for making it easier.

1 Using a pencil, draw a neat, even oval shape – you could even use a stencil for this. Divide your oval into four equal portions, using a ruler if you prefer.

2 Using the guidelines to help you, give your face more shape. Make it taper towards a point at the chin, centred on the vertical guide. Draw ears at the sides, roughly in line with the horizontal guide.

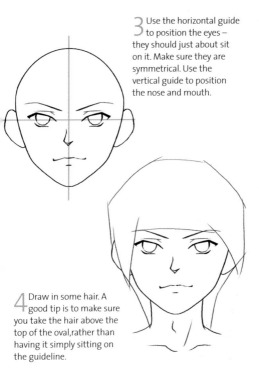

3 Use the horizontal guide to position the eyes – they should just about sit on it. Make sure they are symmetrical. Use the vertical guide to position the nose and mouth.

4 Draw in some hair. A good tip is to make sure you take the hair above the top of the oval, rather than having it simply sitting on the guideline.

▶▶

the male head continued

5 With the basic outline drawn, you can start to add more detail and, finally, colour. Start by erasing any guidelines that you do not want to appear in your completed work.

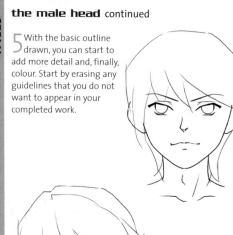

6 Using black ink now, go over your pencil drawing, adding more detail at the same time. Start to work on the eyes (see pages 74–75) and the hair (see pages 98–101).

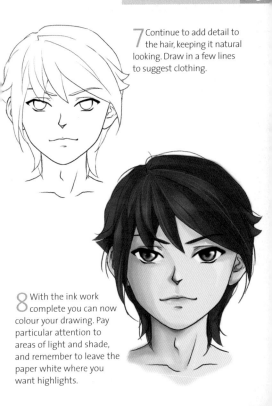

7 Continue to add detail to the hair, keeping it natural looking. Draw in a few lines to suggest clothing.

8 With the ink work complete you can now colour your drawing. Pay particular attention to areas of light and shade, and remember to leave the paper white where you want highlights.

male head: side view

Drawing the male head from the side uses similar principles as drawing the male head face on.

1 Draw an oval. This time, angle it a little to one side. When drawing in your guidelines, move them slightly off-centre, towards the back of the head.

2 Shape the head, adding a nose and neckline. Position the ear just below where the guidelines meet.

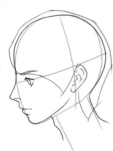

3 Now add a rough outline for the hair and draw in your facial features. (See page 77 for drawing a nose in profile and page 79 for the mouth).

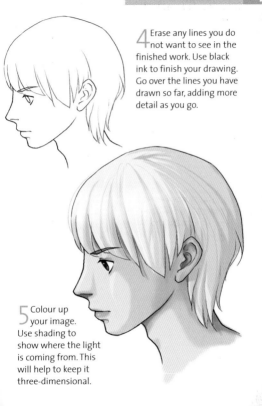

4 Erase any lines you do not want to see in the finished work. Use black ink to finish your drawing. Go over the lines you have drawn so far, adding more detail as you go.

5 Colour up your image. Use shading to show where the light is coming from. This will help to keep it three-dimensional.

male head: 45 degrees

Being able to draw the male head at a 45-degree angle will give your more scope for drawing figures in action.

1 Draw an oval, angled slightly to one side, and with the guidelines three-quarters of the way across. Sketch in the neck.

2 Give more shape to the head and use the guides to draw in the visible ear.

3 Add an outline for the hair, and draw in your facial features. (See pages 77 and 79).

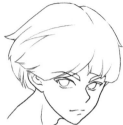

4 Erase any lines you do not want to see in the finished work. Use black ink to go over the lines you have drawn so far and add more detail as you go.

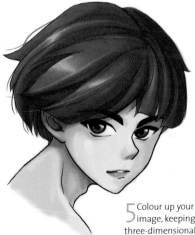

5 Colour up your image, keeping it three-dimensional.

GALLERY

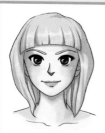

PLACID
An even expression, with wide eyes and sealed lips.

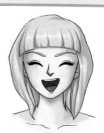

LAUGHING
An open, triangular mouth. The eyes are closed and gently shaped.

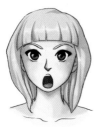

SURPRISED
An open, oval mouth, with eyebrows raised.

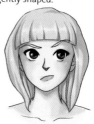

QUIZZICAL
One eyebrow and the corner of the mouth raised.

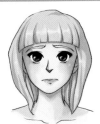

THOUGHTFUL

The eyes are open wide, the eyebrows and mouth slightly dipped.

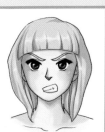

ANGRY

The eyebrows are arched. The mouth is angled, with teeth bared.

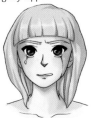

HURT

Tears emerging from wide eyes, trembling lips.

SAD

Lowered, downcast eyes, and a downturned mouth.

GALLERY

PLACID
An even expression, with wide eyes and sealed lips.

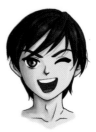

CHEEKY
Winking with one eye and a friendly, open smile.

SURPRISED
Eyes wide open, the mouth is a narrow oval.

QUIZZICAL
One eyebrow and the corner of the mouth raised.

SAD
Wide, doleful eyes and
trembling lips.

HURT
Tears streaming and an
open, downturned mouth.

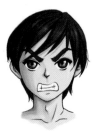

ANGRY
Arched eyebrows, with
teeth bared.

INNOCENT
Expressionless eyes, and
a small oval mouth.

drawing hair

There are several different ways of drawing hair. The same techniques apply to girls and boys.

LEFT This is the simplest style, with the outline drawn and left with no additional detail or colour.

RIGHT You can work on the simplest style by adding flat colour and soft highlights.

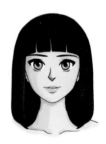

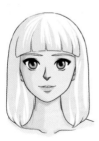

LEFT You can work on the simplest style by adding more tone.

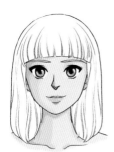

LEFT This is the complex style, with greater detail drawn in ink to make the hair look soft.

RIGHT You can work on a more complex style by adding colour and detailed highlights.

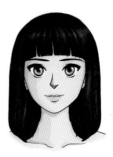

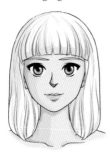

LEFT You can work on the complex style by adding more tone.

short hair with fringe

Some female characters will have short hair. The following steps show how to achieve this in a dark colour.

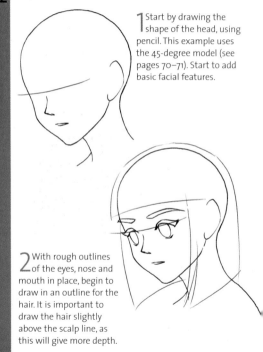

1 Start by drawing the shape of the head, using pencil. This example uses the 45-degree model (see pages 70–71). Start to add basic facial features.

2 With rough outlines of the eyes, nose and mouth in place, begin to draw in an outline for the hair. It is important to draw the hair slightly above the scalp line, as this will give more depth.

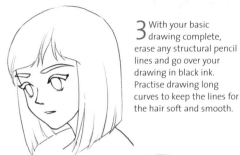

3 With your basic drawing complete, erase any structural pencil lines and go over your drawing in black ink. Practise drawing long curves to keep the lines for the hair soft and smooth.

4 Colour the hair, in this case, black. Build up realistic tones in the hair by adding shadows and highlights. This will help to keep it three-dimensional.

long curling blonde hair

Some female characters will have long hair. The following steps show how to achieve this in a light colour.

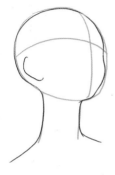

1 Start by drawing the shape of the head, using pencil. This example uses the 45-degree model (see pages 70–71). Draw in the neck and shoulder line.

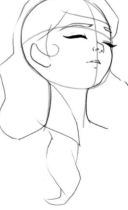

2 With facial features in place, draw in an outline for the hair, keeping it loose. Consider how the hair will flow down over the shoulders.

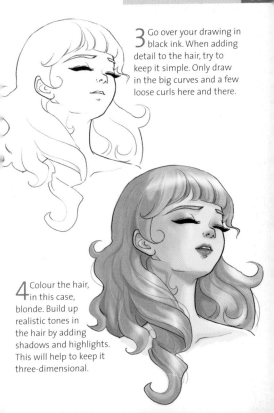

3 Go over your drawing in black ink. When adding detail to the hair, try to keep it simple. Only draw in the big curves and a few loose curls here and there.

4 Colour the hair, in this case, blonde. Build up realistic tones in the hair by adding shadows and highlights. This will help to keep it three-dimensional.

short spiky hair

The majority of male characters will have short hair. It can be fun to give it more shape sometimes.

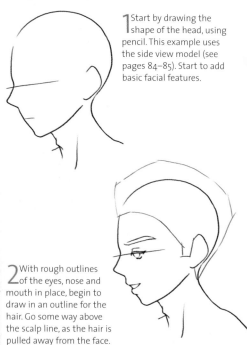

1 Start by drawing the shape of the head, using pencil. This example uses the side view model (see pages 84–85). Start to add basic facial features.

2 With rough outlines of the eyes, nose and mouth in place, begin to draw in an outline for the hair. Go some way above the scalp line, as the hair is pulled away from the face.

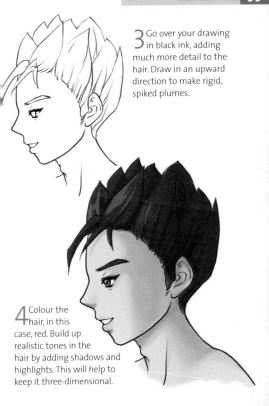

3 Go over your drawing in black ink, adding much more detail to the hair. Draw in an upward direction to make rigid, spiked plumes.

4 Colour the hair, in this case, red. Build up realistic tones in the hair by adding shadows and highlights. This will help to keep it three-dimensional.

graduated hair

Although male figures have short hair, it is often soft and slightly graduated.

1 Start by drawing the shape of the head, using pencil. This example uses the 45-degree model (see pages 86–87). Draw in basic facial features and the neck and shoulder line.

2 With rough outlines of the eyes, nose and mouth in place, begin to draw in an outline for the hair. It is important to draw the hair slightly above the scalp line, as this will give more depth.

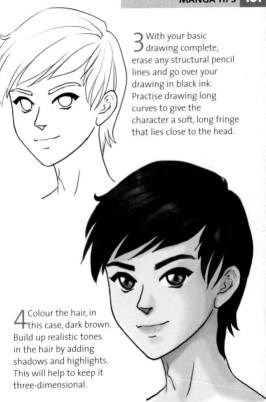

3 With your basic drawing complete, erase any structural pencil lines and go over your drawing in black ink. Practise drawing long curves to give the character a soft, long fringe that lies close to the head.

4 Colour the hair, in this case, dark brown. Build up realistic tones in the hair by adding shadows and highlights. This will help to keep it three-dimensional.

GALLERY

BELOW Short, richly coloured hair that lies close to the head, with a deep fringe.

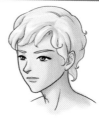

ABOVE Short, soft-toned hair that follows the shape of the head, with soft curls.

BELOW Graduated hair, with a long fringe falling gently over the forehead.

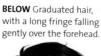

ABOVE Short, spiked hair, pulled away from the face.

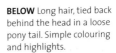

BELOW Long hair, tied back behind the head in a loose pony tail. Simple colouring and highlights.

ABOVE Loose hair with plenty of volume and soft curls. Flat colour with simple highlights.

BELOW Long, richly coloured hair with a fringe and natural curls.

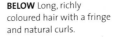

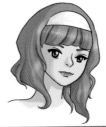

ABOVE Long, loose, flowing hair, cascading around the face and over the shoulders.

an open hand

When it comes to drawing an open hand, palm facing upwards, there are a few tips for making it easier.

1 Using pencil, start your drawing with a few basic shapes. Draw an oval for the palm of the hand and three simple wedges for the thumb, fingers and wrist.

2 Draw in the fingers and thumb, giving them more shape. Bear in mind that the fingers need to be different lengths. Use a photo for reference, if it helps.

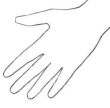

3 Pull your shapes together by drawing a smooth, continuous outline, rounding off the fingertips and shaping the wrist.

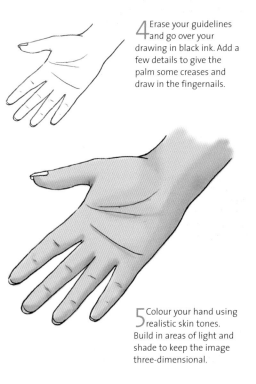

4 Erase your guidelines and go over your drawing in black ink. Add a few details to give the palm some creases and draw in the fingernails.

5 Colour your hand using realistic skin tones. Build in areas of light and shade to keep the image three-dimensional.

a clenched fist

A clenched fist can add a new dimension to your manga character, raised to show anger, solidarity or victory.

1 Using pencil, start with a few basic shapes. Draw an oval for the fist and angled forms for the clenched fingers and thumb. Draw in a couple lines to show the position of the wrist.

2 You need to build on the fist shape. Draw a basic outline for the thumb, so that it hooks around the angled form that represents the fingers.

3 Now draw in each individual finger, bent at the knuckles and tucked into the palm of the hand. Look at the profile of your own clenched fist, if it helps.

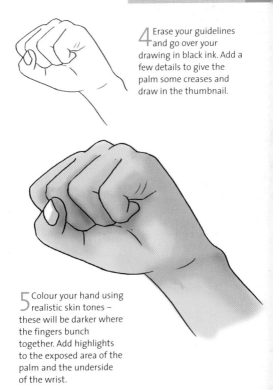

4 Erase your guidelines and go over your drawing in black ink. Add a few details to give the palm some creases and draw in the thumbnail.

5 Colour your hand using realistic skin tones – these will be darker where the fingers bunch together. Add highlights to the exposed area of the palm and the underside of the wrist.

GALLERY

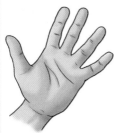

LEFT A male hand, palm up. Men's hands tend to be larger than women's. They have bigger knuckles and thicker fingers.

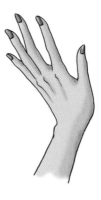

RIGHT A woman's hand with painted nails. This example is thinner and more bony than a normal hand – the knuckles show more clearly.

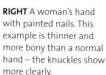

LEFT A more realistic female hand, with slender wrist and long fingers. The lines are smoother and more delicate.

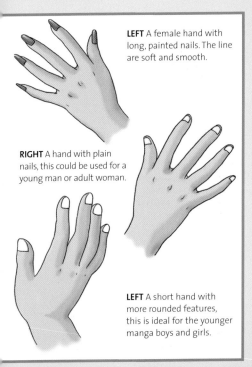

LEFT A female hand with long, painted nails. The line are soft and smooth.

RIGHT A hand with plain nails, this could be used for a young man or adult woman.

LEFT A short hand with more rounded features, this is ideal for the younger manga boys and girls.

hand positions

Having learnt how to draw basic hand shapes, here are a few different positions to practise for more variety.

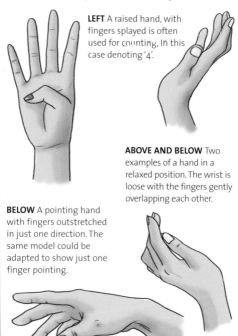

LEFT A raised hand, with fingers splayed is often used for counting. In this case denoting '4'.

ABOVE AND BELOW Two examples of a hand in a relaxed position. The wrist is loose with the fingers gently overlapping each other.

BELOW A pointing hand with fingers outstretched in just one direction. The same model could be adapted to show just one finger pointing.

LEFT An elegant hand, fingers outstretched as if stroking something soft or precious.

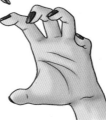

RIGHT A grasping hand, clawing at the air. The palm is stiff and the fingers rigid.

BELOW The 'thumb's up', a universal signal that all is well and good.

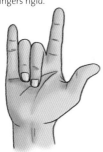

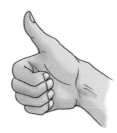

ABOVE Palm raised with two fingers bent. The same model could be adapted with any combination of bent fingers.

GALLERY

RIGHT A standard foot shape, viewed from the side. Although seen in profile, all of the toes are visible, to give more perspective.

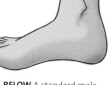

BELOW A standard male foot, viewed face on. The structure is generally more bony than that of the female, and the toes slightly bigger.

ABOVE A standard female foot, with painted nails. The foot is gently shaped, with smooth, elegant features.

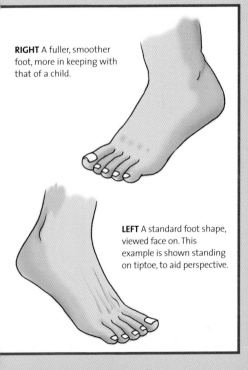

RIGHT A fuller, smoother foot, more in keeping with that of a child.

LEFT A standard foot shape, viewed face on. This example is shown standing on tiptoe, to aid perspective.

foot front view

These instructions are for drawing a right foot, face on. The same principles apply for men and women.

1 Start by drawing a very basic outline in pencil, bearing in mind that you need to show perspective. Use angled forms for the foot and toes, and two simple lines for the ankle.

2 Start to give the foot a more defined shape, capturing the narrowing of the foot and drawing in the ankle bones as they rise up.

3 Pull your shapes together, by drawing one, smooth continuous outline. Draw in each of the toes.

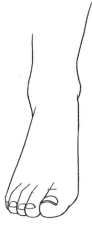

4 Erase your guidelines and go over your drawing in black ink. Add a few details to give the toes some creases and draw in the toenails.

5 Colour your foot using realistic skin tones. Build in areas of light and shade to keep the image three-dimensional. Paint the toenails, if you like. A male foot could have a more bony structure.

foot side view

These instructions are for drawing a right foot, side on. The same principles apply for men and women.

1 Start by drawing an outline in pencil. Use three basic angular shapes to draw the toe area, foot area and ankle.

2 Start to give the foot a more defined shape. Try to capture accurately the line of the sole as it stretches from the big toe to the heel.

3 Pull your shapes together by drawing a smooth, continuous outline. Draw in any toes that are visible and give the ankle bone more definition.

4 Erase your guidelines
and go over your
drawing in black ink using a
firm, fluid line. Draw in any
toenails that are visible.

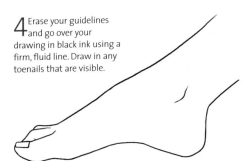

5 Colour your foot using
realistic skin tones.
Build in areas of light and
shade to keep the image
three-dimensional.

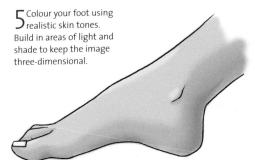

feet positions

Having learnt how to draw basic feet shapes, here are a few different positions to practise for more variety.

ABOVE A young male foot, viewed from 45 degrees. The sole of the foot is just visible beneath the toes.

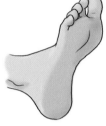

ABOVE A male foot viewed from below, with simple ink lines to give definition to the sole and ankle.

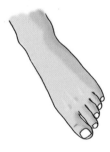

ABOVE A young female foot viewed from above. The bony structure above the toes is just visible.

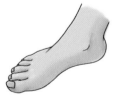

ABOVE A young female foot viewed from 45 degrees, with painted toenails.

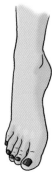

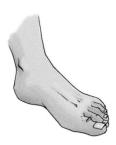

ABOVE A female foot with painted toenails, viewed face on and standing on tiptoe.

ABOVE The more bony structure of an adult male foot, viewed at 45 degrees.

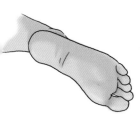

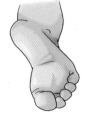

ABOVE A male foot viewed from below. The ankle is foreshortened to show perspective.

ABOVE Another view of a male foot from below, as if stepping away.

girl's tube top

The boob tube is a popular choice for manga girls, it is tight-fitting, and closely follows the shape of the female body.

1 Start with your drawing of the female body (see pages 26–28). The boob tube looks best on a young slim-built figure. Use pencil to get the shape right.

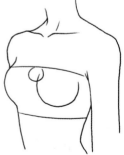

2 Draw the basic outline of the boob tube – in essence, a narrow strip that covers the girl's chest. Make sure you get the perspective right.

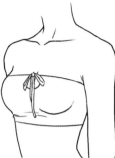

3 Erase any unwanted pencil lines and go over your outline in black ink. Add more detail to the tube, drawing in the ribbon tie. The fabric stretches over the chest area, but is looser just below, so you need a few wrinkles here.

4 Colour up your drawing, adding decorative details here and there. In order to render the smoothness of the fabric, you need highlights on those areas that face the light.

girl's t-shirt

This is a girl's plain cotton T-shirt – soft and stretchy. You can vary the neckline and colouring to suit.

1 Start with your drawing of the female body (see pages 26–28). The cotton T-shirt works best on a slim, youthful figure. Use pencil to get the shape right.

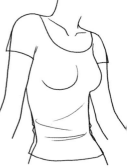

2 Draw the basic outline of the T-shirt – making it stretch across the chest area, and looser around the waist. Draw a few wrinkles where the fabric bunches.

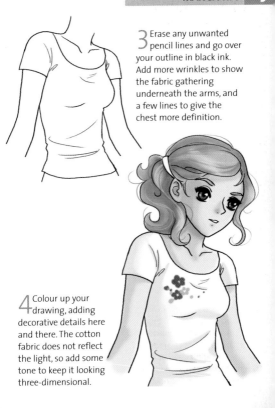

3 Erase any unwanted pencil lines and go over your outline in black ink. Add more wrinkles to show the fabric gathering underneath the arms, and a few lines to give the chest more definition.

4 Colour up your drawing, adding decorative details here and there. The cotton fabric does not reflect the light, so add some tone to keep it looking three-dimensional.

woman's silk blouse

The silk blouse is a fairly loose garment and is suitable for any female figure.

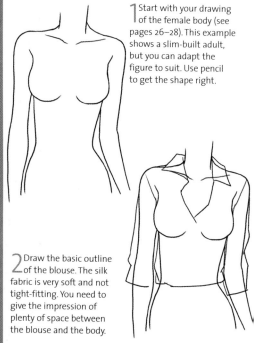

1 Start with your drawing of the female body (see pages 26–28). This example shows a slim-built adult, but you can adapt the figure to suit. Use pencil to get the shape right.

2 Draw the basic outline of the blouse. The silk fabric is very soft and not tight-fitting. You need to give the impression of plenty of space between the blouse and the body.

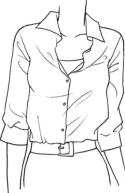

3 Erase unwanted pencil lines and go over your outline in black ink. Add wrinkles to show the looseness of the fabric, and how it buckles under the weight of the collar.

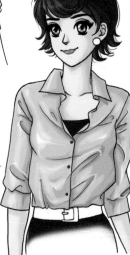

4 Colour up your drawing. The silk fabric is very shiny and highly reflective, so you need to add plenty of highlights where it catches the light.

woman's pencil skirt

The pencil skirt is a manga favourite, as it hugs the body, giving a very feminine look.

1 Start with your drawing of the female body (see pages 26–28). The pencil skirt works best on a slim-built figure. Use pencil to get the shape right.

2 Draw the basic outline of your skirt. A pencil skirt tends to be tight-fitting across the hips, and tapering as it drops to just above the knees.

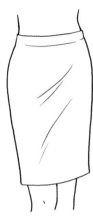

3 Erase unwanted pencil lines and go over your outline in black ink. Draw in some wrinkles to show the stretch of the fabric.

4 Colour up your drawing, adding a few highlights on the side facing the light, and to accentuate the wrinkles across the hips.

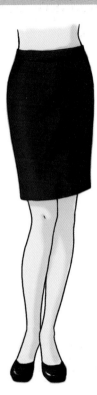

woman's jeans

Although blue jeans are the obvious choice, you can use this model to draw any heavier-weight trousers.

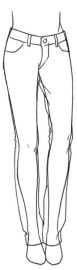

2 Draw the basic outline of your jeans. Denim is a stiff fabric, so your lines need to reflect this. Draw rigid lines to show where the fabric is loose.

1 Start with your drawing of the female body (see pages 26–28). Blue jeans look good on a tall, slim figure. Use pencil to get the shape right.

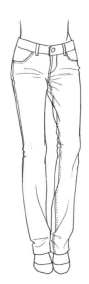

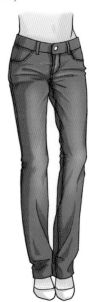

4 Colour up your drawing. Add highlights to show where the denim catches the light, and to give more body to the stiff wrinkles.

3 Erase unwanted pencil lines and go over your outline in black ink. Draw in plenty of detail here, adding seams, pockets and a waistband. Add wrinkles around the shins and down the inner thigh.

woman's full skirt

The full skirt is a fairly loose garment and can be worn by any female figure.

1 Start with your drawing of the female body (see pages 26–28). This example shows a youthful female, but you can adapt the figure to suit. Use pencil to get the shape right.

2 Draw the basic outline of your skirt. A full skirt tends to be snug at the waist, but flares out from here to the knees. Keep your lines fluid to capture the movement of the fabric.

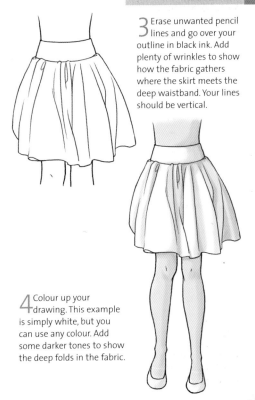

3 Erase unwanted pencil lines and go over your outline in black ink. Add plenty of wrinkles to show how the fabric gathers where the skirt meets the deep waistband. Your lines should be vertical.

4 Colour up your drawing. This example is simply white, but you can use any colour. Add some darker tones to show the deep folds in the fabric.

GALLERY

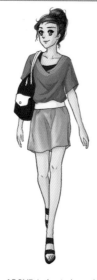

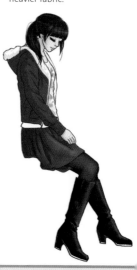

BELOW A wool fleece worn with a silk skirt. The wrinkles on the fleece are more rigid to show the heavier fabric.

ABOVE A short-sleeved loose-fitting cotton top worn with a simple silk miniskirt. Lines are soft and flowing.

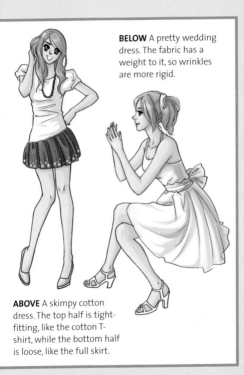

BELOW A pretty wedding dress. The fabric has a weight to it, so wrinkles are more rigid.

ABOVE A skimpy cotton dress. The top half is tight-fitting, like the cotton T-shirt, while the bottom half is loose, like the full skirt.

man's cotton vest

This is a man's plain cotton vest – soft and stretchy, these tend to be tight on the body.

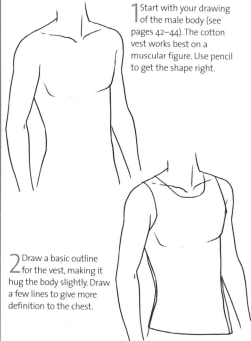

1 Start with your drawing of the male body (see pages 42–44). The cotton vest works best on a muscular figure. Use pencil to get the shape right.

2 Draw a basic outline for the vest, making it hug the body slightly. Draw a few lines to give more definition to the chest.

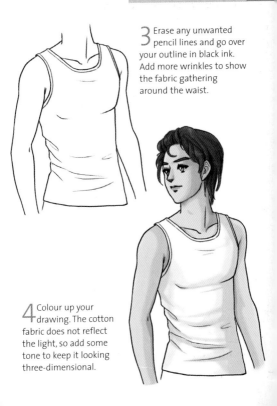

3 Erase any unwanted pencil lines and go over your outline in black ink. Add more wrinkles to show the fabric gathering around the waist.

4 Colour up your drawing. The cotton fabric does not reflect the light, so add some tone to keep it looking three-dimensional.

boy's loose t-shirt

The loose T-shirt is great for any male figure. You can adapt the shape of the neckline to suit.

1 Start with your drawing of the male body (see pages 42–44). This example shows a youthful boy, but you can change the figure to suit. Use pencil to get the shape right.

2 Draw the basic outline of the T-shirt. The fabric is very soft and not at all tight-fitting. You need to give the impression of plenty of space between the T-shirt and the body.

3 Erase unwanted pencil lines and go over your outline in black ink. Add wrinkles to show the looseness of the fabric, particularly in the abdominal area and under the arms.

4 Colour up your drawing, using one or more colours. The cotton fabric does not reflect light, so add tone to keep it looking three-dimensional.

man's shirt

A shirt is a fairly loose garment and is suitable for any male figure. Draw short or long sleeves to suit.

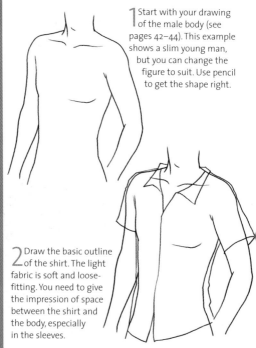

1 Start with your drawing of the male body (see pages 42–44). This example shows a slim young man, but you can change the figure to suit. Use pencil to get the shape right.

2 Draw the basic outline of the shirt. The light fabric is soft and loose-fitting. You need to give the impression of space between the shirt and the body, especially in the sleeves.

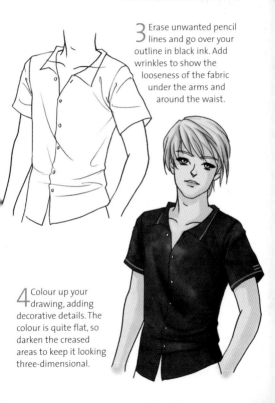

3 Erase unwanted pencil lines and go over your outline in black ink. Add wrinkles to show the looseness of the fabric under the arms and around the waist.

4 Colour up your drawing, adding decorative details. The colour is quite flat, so darken the creased areas to keep it looking three-dimensional.

man's suit jacket

The suit jacket is quite a formal item of clothing, and is suitable for any adult male figure.

1 Start with your drawing of the male body (see pages 42–44). This example shows a slim young man, but you can change the figure to suit. Use pencil to get the shape right.

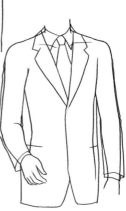

2 Draw the basic outline of the jacket. The material is stiff and hangs straight from the chest, without following the shape of the body. Draw in the lapels and add a shirt and tie underneath.

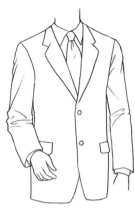

3 Erase unwanted pencil lines and go over your outline in black ink. Add details such as pockets and buttons. Because the fabric is stiff, wrinkles only appear where there is movement in the arms.

4 Colour up your drawing. Most suit fabrics have a slight sheen to them, so add highlights where the material catches the light. Otherwise, keep the colour quite flat.

men's jeans

Men's jeans tend to be looser fitting than women's jeans, but have a similar weight to the fabric.

2 Draw the basic outline of your jeans, keeping plenty of space between the denim and the legs. Keep the lines rigid to show the stiff fabric.

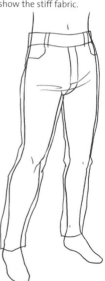

1 Start with your drawing of the male body (see pages 42–44). Use pencil to get the shape right.

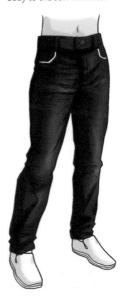

4 Colour up your drawing. Add highlights to show where the denim catches the light, and to give more body to the stiff wrinkles.

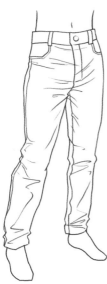

3 Erase unwanted pencil lines and go over your outline in black ink. Add wrinkles all the way down the legs to show a lose fit.

men's leather trousers

Leather trousers are a manga favourite, as they add a rugged masculinity to the character.

2 Draw the basic outline of the trousers, keeping plenty of space between the leather and the legs. Keep the lines rigid to show the stiff fabric.

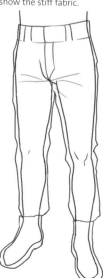

1 Start with your drawing of the male body (see pages 42–44). Use pencil to get the shape right.

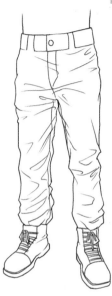

4 Colour up your drawing. Be sure to add plenty of highlights to show the smoother, deeper creases of the leather fabric.

3 Erase unwanted pencil lines and go over your outline in black ink. Add wrinkles all the way down the legs to show the thickness of the heavy leather.

GALLERY

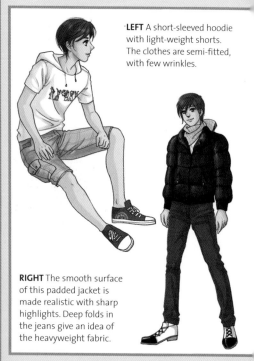

LEFT A short-sleeved hoodie with light-weight shorts. The clothes are semi-fitted, with few wrinkles.

RIGHT The smooth surface of this padded jacket is made realistic with sharp highlights. Deep folds in the jeans give an idea of the heavyweight fabric.

LEFT A thick fleece with cargo pants. Deep creases show the bagginess of the trousers and thickness of the fleece.

RIGHT A rugby shirt with lightweight trousers. Both items of clothing have big folds to show a looser fit.

kukri knife

This is a primitive-looking tool, with short handle and a wide, curved blade. It is very easy to draw.

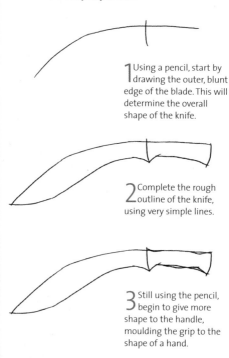

1 Using a pencil, start by drawing the outer, blunt edge of the blade. This will determine the overall shape of the knife.

2 Complete the rough outline of the knife, using very simple lines.

3 Still using the pencil, begin to give more shape to the handle, moulding the grip to the shape of a hand.

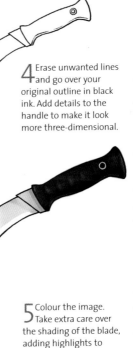

4 Erase unwanted lines and go over your original outline in black ink. Add details to the handle to make it look more three-dimensional.

5 Colour the image. Take extra care over the shading of the blade, adding highlights to achieve a metal finish.

katana

The archetypal samurai sword has a long, slender, single-edged blade and a grip big enough for two hands.

1 Using a pencil, start by drawing a skeletal structure for the sword, to get the proportions right. The blade should make up at least two-thirds of the weapon and should be gently curved.

2 With the proportions set, and still using pencil, draw the basic sword shape. The blade should taper almost to a point at the end.

3 Erase unwanted lines and go over your drawing using black ink. Add details, such as the guard at the base of the grip and the bevel on the blade.

4 Colour the image. Take extra care over the shading of the blade. Add highlights to achieve a metal finish and to show the direction of the bevel.

bow and arrow

The bow and arrow is a popular manga weapon. It will take a bit of practice to get the perspective right.

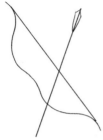

1 Using a pencil, start by drawing the basic shape of the bow and arrow, taking care to get the perspective right, particularly if being held.

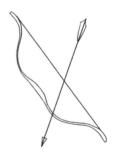

2 Build on your drawing, giving the bow a solid frame and the arrow its spearhead.

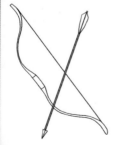

3 Work on the three-dimensionality of both bow and arrow. Draw in the central section of the bow which will be the grip for the hand.

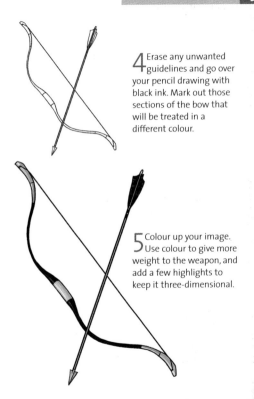

4 Erase any unwanted guidelines and go over your pencil drawing with black ink. Mark out those sections of the bow that will be treated in a different colour.

5 Colour up your image. Use colour to give more weight to the weapon, and add a few highlights to keep it three-dimensional.

hand gun

It is very easy to draw a handgun as its structure is based on just a few simple shapes.

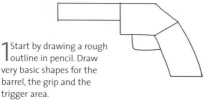

1 Start by drawing a rough outline in pencil. Draw very basic shapes for the barrel, the grip and the trigger area.

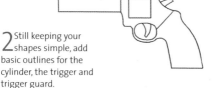

2 Still keeping your shapes simple, add basic outlines for the cylinder, the trigger and trigger guard.

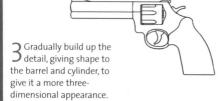

3 Gradually build up the detail, giving shape to the barrel and cylinder, to give it a more three-dimensional appearance.

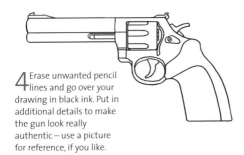

4 Erase unwanted pencil lines and go over your drawing in black ink. Put in additional details to make the gun look really authentic – use a picture for reference, if you like.

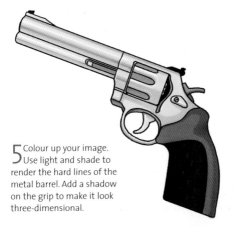

5 Colour up your image. Use light and shade to render the hard lines of the metal barrel. Add a shadow on the grip to make it look three-dimensional.

automatic rifle

Although it looks complicated, the automatic rifle is fairly easy to draw, as long as you get the initial shape right.

1 Use a pencil to draw a rough outline. Having a picture for reference will help with proportions.

2 Still keeping the lines to a minimum, add some more detail to the barrel and the hand grip.

3 Continue to build up detail gradually, taking care to make the rifle look three-dimensional.

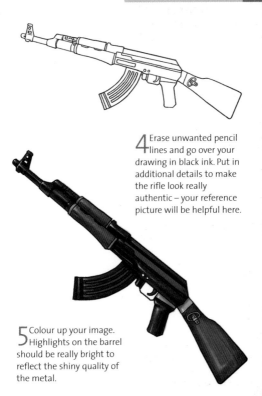

4 Erase unwanted pencil lines and go over your drawing in black ink. Put in additional details to make the rifle look really authentic – your reference picture will be helpful here.

5 Colour up your image. Highlights on the barrel should be really bright to reflect the shiny quality of the metal.

machine gun

Mean and lean, the machine gun is one of the hardest weapons to draw, but is worth effort.

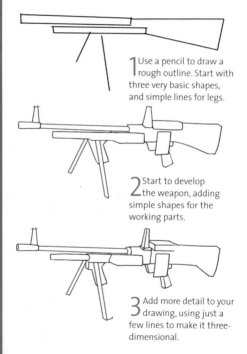

1 Use a pencil to draw a rough outline. Start with three very basic shapes, and simple lines for legs.

2 Start to develop the weapon, adding simple shapes for the working parts.

3 Add more detail to your drawing, using just a few lines to make it three-dimensional.

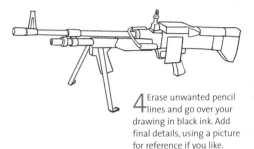

4 Erase unwanted pencil lines and go over your drawing in black ink. Add final details, using a picture for reference if you like. This will keep it real.

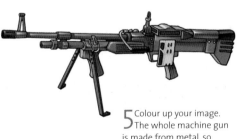

5 Colour up your image. The whole machine gun is made from metal, so take care to build up light and shade. Keep the highlight really bright.

GALLERY

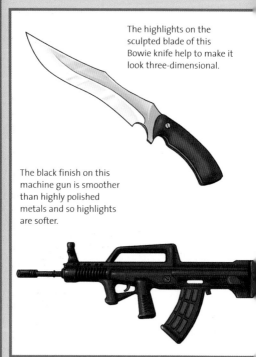

The highlights on the sculpted blade of this Bowie knife help to make it look three-dimensional.

The black finish on this machine gun is smoother than highly polished metals and so highlights are softer.

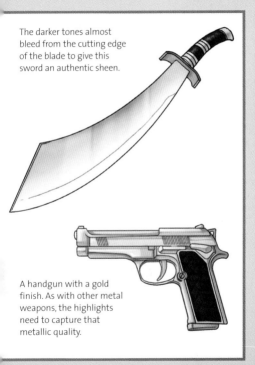

The darker tones almost bleed from the cutting edge of the blade to give this sword an authentic sheen.

A handgun with a gold finish. As with other metal weapons, the highlights need to capture that metallic quality.

bicycle

Bicycles are notoriously difficult to draw. The key to success lies in getting the perspective right.

1 This bike is seen from 45 degrees. Start by drawing the basic structure in pencil – a few lines should do it. Use a stencil to draw the wheels.

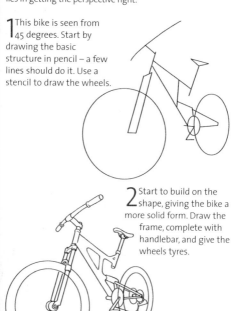

2 Start to build on the shape, giving the bike a more solid form. Draw the frame, complete with handlebar, and give the wheels tyres.

3 Erase unwanted pencil lines and go over your drawing in ink. Add final details, such as the spokes on the wheels.

4 Colour up your image. Use colours sparingly, to keep it realistic and make sure you add brighter highlights where the metal frame catches the light.

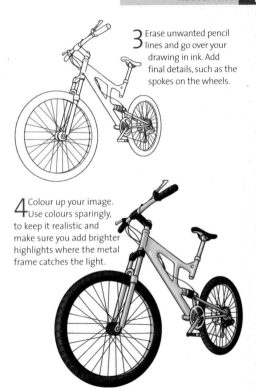

motorbike

Drawing a motorbike is like drawing a bicycle. The same principles apply – it just has more 'muscle'.

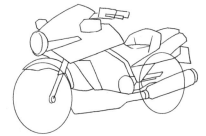

1 Start by drawing the basic structure – a few lines should do it. Use a stencil to draw the wheels.

2 Build on the shape, making it more solid. Add more detail and fatten up the tyres.

3 Erase unwanted pencil lines and go over your drawing in ink. Add final details, taking your time to get them right.

4 Colour up your image. Keep the highlights on the tyres, seat and windshield softer than those on the metal parts to prevent it looking flat.

motor car

This old-fashioned motor car is actually quite simple to draw as its structure is quite geometric.

1 This car is seen from 45 degrees, so consider perspective carefully. Start by drawing the basic structure in pencil, and use a stencil to draw the wheels.

2 Build on your shape, giving the car a more solid form. Give the windscreen a frame, and add tyres to the wheels.

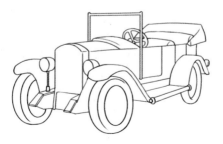

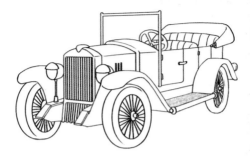

3 Erase unwanted pencil lines and go over your drawing in ink. Add final details, such as the radiator grille.

4 Colour up your image. Choose a strong colour with crisp highlights where the metal catches the light.

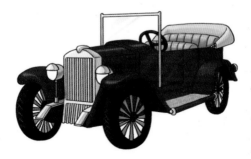

small car

Modern cars tend to have amorphic shapes, which simplifies things when it comes to drawing them.

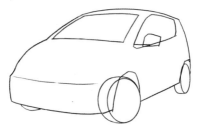

1 Start by drawing the basic structure in pencil. The car is seen from 45 degrees, so consider perspective carefully. Use a stencil to draw the wheels.

2 Build on your shape, giving the car a more solid form. Draw the features on the front and draw the interior through the windows.

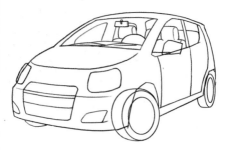

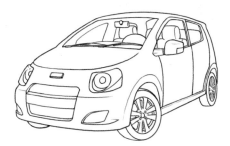

3 Erase any unwanted pencil lines and go over your drawing in ink. Add final details, such as the wheels, headlights and windscreen wipers.

4 Colour up your image. Modern cars often have a plastic quality, so keep the highlights soft to show this.

large car

Whether drawing a Mini or a limousine, the principles for drawing a car are always the same.

1 Start by drawing the basic structure in pencil. The car is seen almost side on, so consider perspective carefully. Use a stencil to draw the wheels.

2 Build on your shape, giving the car a more solid form. Draw the features on the front and start to draw the interior through the windows.

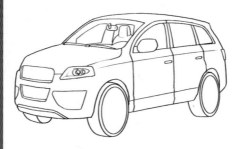

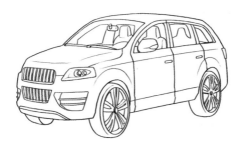

3 Erase unwanted pencil lines and go over your drawing in ink. Add final details, such as the wheels and the radiator grille.

4 Colour up your image. Pay particular attention to the windows, adding strong highlights to prevent them looking flat.

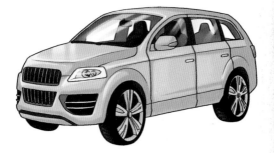

helicopter

Drawing aircraft can be difficult, as they are often seen from below, which makes perspective difficult.

1 This helicopter is seen side on, but also from a lower standing point. Start by drawing the basic structure in pencil.

2 Build on your shape, giving the helicopter a more solid form. Pay particular attention to the rotary blades, as each one is affected by perspective.

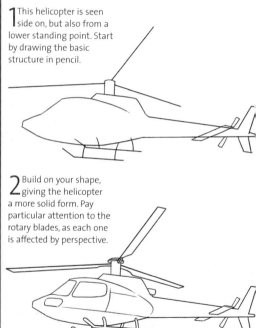

3 Erase unwanted pencil lines and go over your drawing in ink. Add final details to make the aircraft look more authentic.

4 Colour up your image. Use realistic colours to keep it real. Take care with the highlights on the glass, and keep them razor-sharp on the rotary blades.

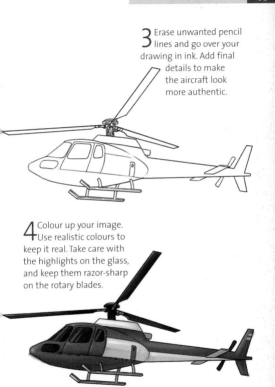

GALLERY

A coupé seen from above. The highlights on the windscreen help to make it look realistic.

Vehicles like this can become a labour of love, with their intricate exposed engines.

An aeroplane, seen from below. Perspective is key when drawing airborne aircraft.

A large people carrier with dark windows. Glass is notoriously difficult to colour realistically.

mecha standing

Mecha, and characters like him, are based on the human form. Just let your imagination run riot.

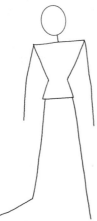

2 Still using pencil, draw basic shapes at the elbows, knees, wrists and ankles, to show where the joints should be.

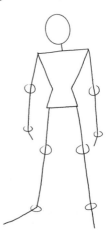

1 Using a pencil, sketch a very rough structure of a figure, just as you would if drawing a man (see pages 42–43). See pages 40–41 for a guide on proportions.

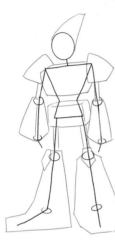

3 With your basic structure complete, begin to give the figure a fuller outline. He is made from metal, so your shapes should be rigid and angular. Use your imagination to create a powerful character.

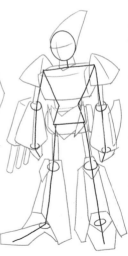

4 Continue to build on your pencil outline, giving more shape to the arms and legs. Begin to add detail to the upper body. Draw in guidelines for the facial features.

▶▶

mecha standing continued

5 Build on the three-dimensionality of your figure, giving the body more form. Draw in rudimentary facial features, albeit armoured ones, and finalise the details.

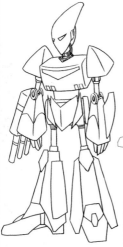

6 Your pencil drawing should now be complete. Refine any of the lines if you need to, before erasing those that you no longer need.

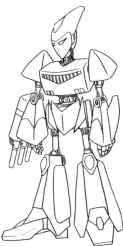

7 Once the pencil drawing is complete, you can finalise it using black ink. Take care to draw over your lines accurately, adding any last details.

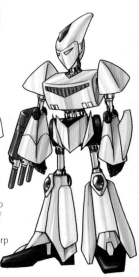

8 Colour up your image. Mecha is fully armoured and you need to capture the stiff quality of his limbs accurately. Keep colours solid – adding sharp highlights where the metal catches the light.

mecha in battle

Battles scenes are frequent events in manga stories. This is a straightforward fighting stance.

1 Using a pencil, sketch a very rough structure of your figure, just as you would if drawing a man (see pages 42–43). See pages 40–41 for a guide on proportions. Consider how he might be standing in battle.

2 Still using pencil, draw basic shapes at the shoulder, hips, knees and so on, to show where the joints should be.

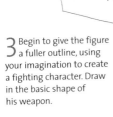

3 Begin to give the figure a fuller outline, using your imagination to create a fighting character. Draw in the basic shape of his weapon.

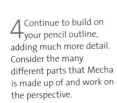

4 Continue to build on your pencil outline, adding much more detail. Consider the many different parts that Mecha is made up of and work on the perspective.

▶▶

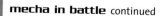

5 Build on the three-dimensionality of your figure, giving the body more form. Add detail to Mecha's weapon, using your imagination to create something otherworldly.

6 Your pencil drawing should now be complete. Refine any of the lines if you need to before erasing those that you no longer need.

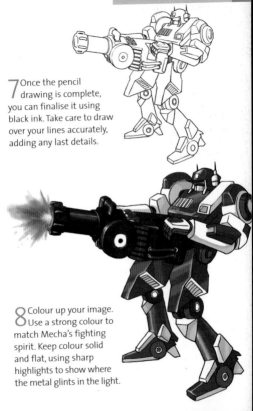

7 Once the pencil drawing is complete, you can finalise it using black ink. Take care to draw over your lines accurately, adding any last details.

8 Colour up your image. Use a strong colour to match Mecha's fighting spirit. Keep colour solid and flat, using sharp highlights to show where the metal glints in the light.

flying mecha

The challenge with this character is to get the perspective right to really give the impression that he is in mid-air.

1 Using a pencil, sketch a very rough structure of your figure. Take time to get the perspective right – his head must seem much bigger, than his feet.

2 Still using pencil, draw basic shapes at the shoulders, elbows, knees and so on, to show where the joints should be.

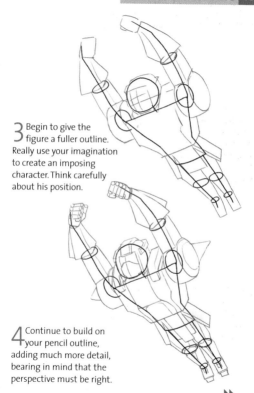

3 Begin to give the figure a fuller outline. Really use your imagination to create an imposing character. Think carefully about his position.

4 Continue to build on your pencil outline, adding much more detail, bearing in mind that the perspective must be right.

▶▶

flying mecha continued

5 Build on the three-dimensionality of your figure, giving the body more form. Try to imitate the accuracy of machine-made robots.

6 Your pencil drawing should now be complete. Refine any of the lines if you need to before erasing those that you no longer need.

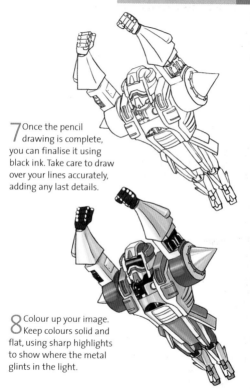

7 Once the pencil drawing is complete, you can finalise it using black ink. Take care to draw over your lines accurately, adding any last details.

8 Colour up your image. Keep colours solid and flat, using sharp highlights to show where the metal glints in the light.

GALLERY

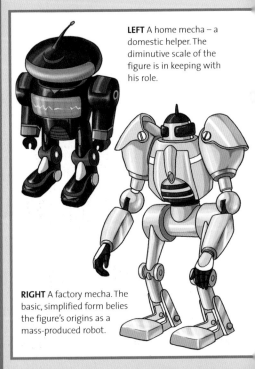

LEFT A home mecha – a domestic helper. The diminutive scale of the figure is in keeping with his role.

RIGHT A factory mecha. The basic, simplified form belies the figure's origins as a mass-produced robot.

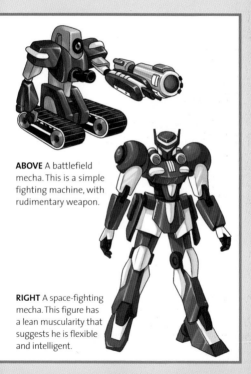

ABOVE A battlefield mecha. This is a simple fighting machine, with rudimentary weapon.

RIGHT A space-fighting mecha. This figure has a lean muscularity that suggests he is flexible and intelligent.

index

index